ADRIAN HILL'S

WHAT SHALL WE DRAW?

written and illustrated by
ADRIAN HILL

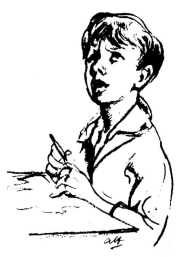

STUDIO
VISTA

Studio Vista

a Cassell imprint

Villiers House, 41/47 Strand
London WC2N 5JE

First published by Blandford Press 1957
Reprinted twelve times
This edition 1994

ISBN 0-289-80104-4

Distributed in the United States by
Sterling Publishing Co. Inc.
387 Park Avenue South, New York, New York 10016

Distributed in Australia by
Capricorn Link (Australia) Pty Ltd
PO Box 665, Lane Cove, NSW 2066

Printed in Great Britain by
Butler & Tanner Ltd, Frome and London

WHAT SHALL WE DRAW?

Contents

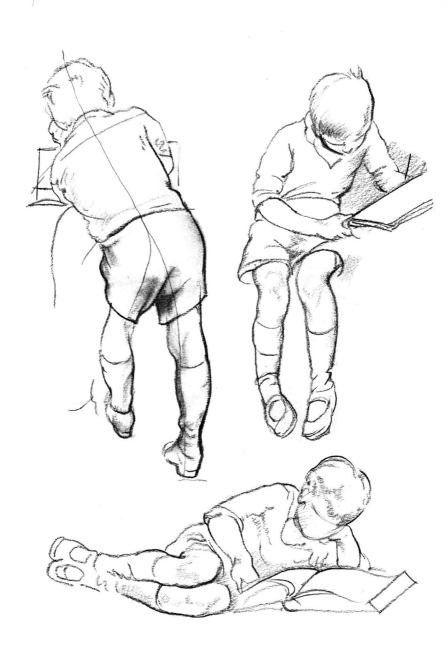

Characteristic positions taken by children when reading or drawing

Preface

IN this revised and enlarged impression of WHAT SHALL WE DRAW? I have taken the opportunity of widening the range of subject-matter, which includes further steps. In the original book I implied that everything is worth drawing; in this edition I have given more examples to prove my point!

I have also added a concluding chapter on the choice of drawing techniques which can be employed, and which are best suited for our purpose.

In this way I hope to help the reader to explore these legitimate technical devices, and thus enjoy even more the pleasures and rewards which can be obtained in mastering the art of drawing.

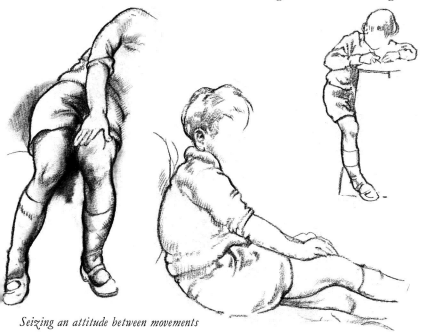

Seizing an attitude between movements

Anatomical accuracy can be sacrificed for a rhythmic design

Introduction

WHAT do we mean by drawing? Or put it this way, what do *we* have to do when we draw something? Isn't it really a question of "how does it go"? Now this is not so very difficult, as long as we are satisfied with making what we are drawing "something like it", but it becomes harder and, of course, more interesting, when we ask ourselves "how does it *really* go?" Because this means making our drawing as much like the object or the scene as we can, as well as we know how! We may be satisfied (and we often are) with "that's good enough", but a good drawing is nearly always the outcome of several attempts, the last of which we know to be an improvement on the first.

So let's go back to our first question—"how does it go?" Can we always rely on our memory? If not, then we must look around and find the actual thing we want to draw. It may be found close at hand, or we may have to go out and find it. In any case, a passing glance, a quick look, and a confident "Oh, yes, I see" is generally not enough. It is only after a good *long* look that we can be satisfied that we have really taken it all in.

So we find that drawing begins with *how* we use our eyes. *What* to look for, and then *how* to look at it, so that we see how it is made, how it works and how it moves. In short, *all about it*. And then, of course, we must make our drawing hand follow faithfully what our eye has correctly seen.

9

Let's Draw a Face

(1)

SUPPOSING we start with a face. How does it go? At a *glance* we see it is *round* and inside this circular shape are two eyes, a nose and a mouth. When we are very young it is generally drawn like this.

Well, I suppose we must all agree this is *something* like a face! The dots do resemble eyes, and the nose and mouth can be suggested by straight lines. But it is a long way from looking like a *real face*. When we look again, and look hard, we see that the eyes are more than dots, and that they move. The mouth can open and shut and the nose *sticks out*. Also the whole head can turn, look up or down, to the right or left.

Now if we try and describe any of these movements without improving on our dots and straight lines, we will only get these results.

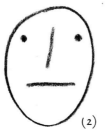

(2)

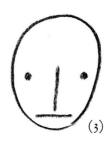

(3)

For although we have moved our dots and straight lines, we haven't got much farther—it is still a "make do". But another

good long look at the eyes will show us how they are made, and how we can make them move in various directions.

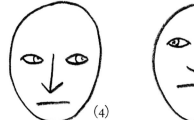 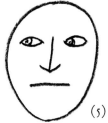 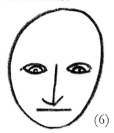

(4) (5) (6)

And at once our face begins to look *alive*! Now for the nose and mouth. We now see that the nose is wedge-shaped—has *two* sides—and the mouth is made of two lips pressed together and can open and shut. So now we get—

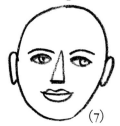 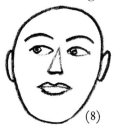 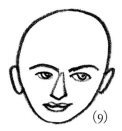

(7) (8) (9)

Another important addition we can now make is eyelids. (Remember that it is the *top* lid which shuts the eye.) Then I think it's time we added the eyebrows and put in the ears—so often forgotten—and not only tried to draw three different kinds of head but gave them three different kinds of expression! For that is where the real fun begins.

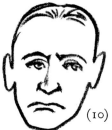 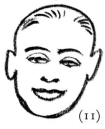 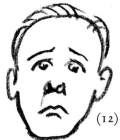

(10) (11) (12)

11

And if we compare these drawings with our first, I think you'll agree that we've used our eyes to great advantage. None of these important details can be taken in at a mere glance, but only become apparent when we concentrate—stare, if you like. In fact, it's the only time when we can stare without being told it's rude! Moreover, I would say that it is only when we are actually drawing something that we really do *see* it. Well, now, what shall we draw next?

How about trying to turn our face in various positions? Before we attempt this, let us just see what a side view of a face looks like. The head can still be drawn round, and the eye (for we only see one now) can be made by a dot, and the mouth (only half will be seen) by a

(13) line, but the nose will now have to be shown to *stick out* beyond the head, as it grows out of it.

But by looking at the features, as we did in the full face, we soon see how we can improve on our dot and lines. We notice that the eye is now triangular rather than quite round, as is also

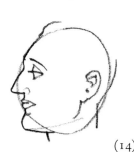

the mouth, because both features are side view, while we now see the *whole* ear, which we couldn't see before, as it is set close to the side of the face.

Lastly, we will take notice of the chin and forehead, and with these additions and improvements we should get a result like this.

(14) Before we go on, it is interesting to note that in a side view the nose always protrudes or sticks out farther than the forehead or chin. From the baby head to old age, this is always the case.

It is very important to remember this because, somehow or other, we must try and show this *projection* when drawing a full

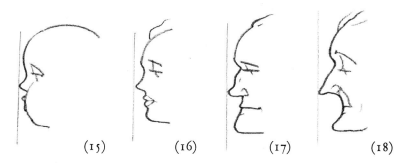

(15) (16) (17) (18)

face, or what we call a three-quarter view, when the face is turned away from us.

So back we come to the nose again. Now, while all noses are different in *shape*, they are all *constructed* the same way. If you look at the next five drawings, you will see what I mean.

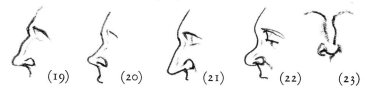

(19) (20) (21) (22) (23)

And now for the most important thing of all. It is this—that the head we have been looking at is *SOLID*. How can we show this?

One way, and I think a good one, is to imagine the head we are drawing is shaped like an egg (24). If we draw a string tied *round* the egg, we must use a *curved* line, and not a *straight* one. Compare (25) with (26) and (27), and you'll see what I'm getting at.

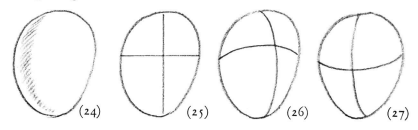

(24) (25) (26) (27)

13

Now we can make use of these curved lines when we draw a three-quarter view of the head or when it is raised or lowered. Look at the following diagrams and you will see how it works.

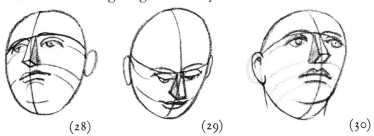

(28) (29) (30)

Notice that the ear, which is generally set between the corner of the eyes and the wing of the nostril, moves *up* and *down* according to the position of the face. And because of their position, the ears are only seen *full face* when the head is turned *sideways*. For this reason, when we are face to face with our sitter, his ears appear very foreshortened and very difficult to draw. Make studies. Their shapes vary as much as noses and mouths, which is saying something!

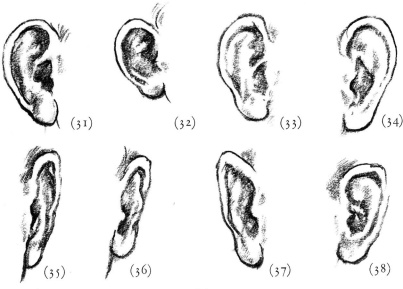

(31) (32) (33) (34)

(35) (36) (37) (38)

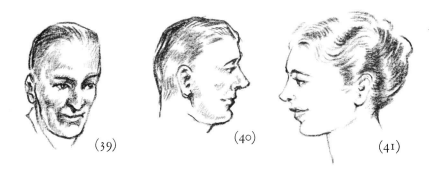

(39)　　　　(40)　　　　(41)

The more you practise faces, the better they'll become, and you'll find yourself attempting different types of people—such as I've suggested here:

Incidentally, from long experience in beginners' drawings, noses are generally drawn *far too long*, and the eyes are set too close together.

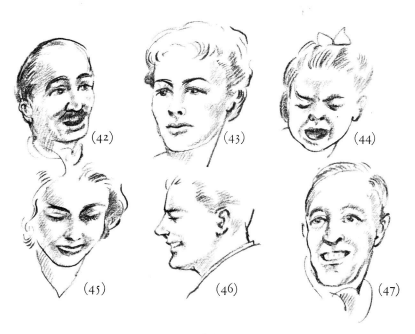

(42)　　　　(43)　　　　(44)

(45)　　　　(46)　　　　(47)

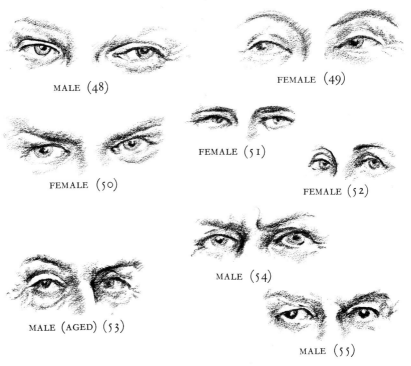

MALE (48)

FEMALE (49)

FEMALE (50)

FEMALE (51)

FEMALE (52)

MALE (AGED) (53)

MALE (54)

MALE (55)

Eyes are the most important feature in drawing a portrait. Their shape actually changes with some movements, for not only do they portray character but they express all sorts of emotions. They become puckered with laughter, narrowed with suspicion, dilated with doubt or fear. They sparkle with delight and droop with weariness and close with sleep.

(56) (57) (58)

Many similar changes take place in the mouth, in laughter and tears, when we smile, cough, pout, yawn, purse our lips, or bite them. They are constantly in motion when talking or, rather more slowly, when munching a bun.

And remember that while it is the *upper* lid which shuts the eye, it is the *lower* lip which closes the mouth.

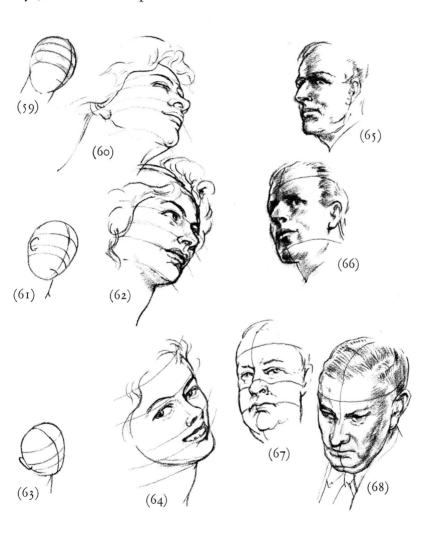

(59)

(60)

(65)

(61)

(62)

(66)

(63)

(64)

(67)

(68)

Let's Draw a Man

I SUPPOSE our very first attempts at drawing a man were something like this.

Well, as I said of the first efforts in drawing a face, it is *something* like—anyhow, more like—a human being than an animal! It is standing; it's got a head, arms and legs, and although only a single line is used for the body, it does somehow suggest a body. But again, it is a very long way from looking like a *real* person. And the first thing we've got to do to make it real is to make it *solid*. And I think the best way to do this is to imagine that our man is composed of a series of tubes of various lengths and thicknesses. These tubes will represent the arms and legs and neck. For the body—let us imagine it like, well, like a rolled-up napkin, because this is *soft* and can *bend*. When you put your napkin in a ring, you can bend it backwards and forwards.

(69)

(70)

18

Now imagine that we insert the bottom of the napkin into a shallow basin.

(71)

Now we've got something like the body—a bendable trunk with a solid base to it.

We can use the same egg-like shape for the head, which we can now fix to the top of the trunk by a short cylinder or tube, and that is our neck.

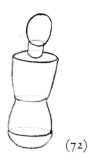

(72)

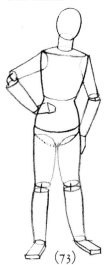

(73)

Next, the arms, also tubes, but longer than the neck. And you will notice that they bend in the middle, so that we have two parts, an upper and a lower arm. Now the legs—*thicker* than the arms, but, like them, composed of an upper and a lower part, with a joint which is the knee. For the time being, the hands and feet can be thought of as solid.

Do you see the idea? We have con-structed a solid rounded body which can *stand*. Of course, the arms and legs are not as simple as I've drawn them, but they can move, and they and our simplified body represent something that we can put clothes on, and it is very helpful, when we come to draw people, to know that there is a solid form underneath the clothes.

Now, the human body is one of nature's most wonderful machines and we should now know something about the way it moves. I've explained that the trunk can bend backwards and forwards, but not very far backwards because our backbone is just underneath our skin and (unless we are contortionists or

acrobats) it is our backbone (which is made up of a series of bones) which prevents our bending completely over backwards. Look at (74) and (75) and you'll see why.

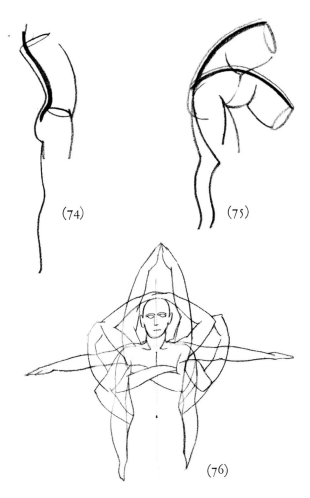

(74)

(75)

(76)

On the other hand, our arms and legs, especially our arms, can move in many directions (76). Can you follow them all? And, side view, a complete circle can be formed by swinging our arm over our head.

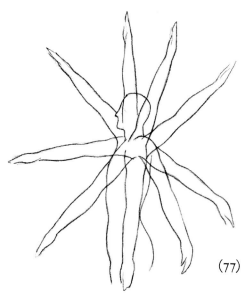

(77)

Now let us take the leg movements. Not quite so many as the arms, but we must remember that when the legs are braced they support the whole body, and when we lift one leg, the remaining leg can easily carry the weight of the body. Also notice how the leg can fold up like a ruler, when we draw up our knees while sitting on the ground.

(78)

21

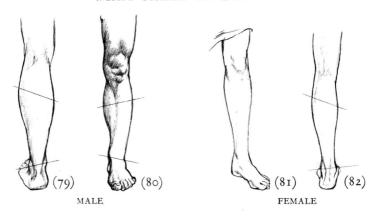

(79) (80) (81) (82)

MALE FEMALE

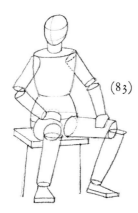

(83)

From the movements (78) I hope you can see the sitting, kicking, walking and running actions—in fact all you want for a figure in motion. This knowledge should make it easier (I don't say easy) for drawing a man sitting down.

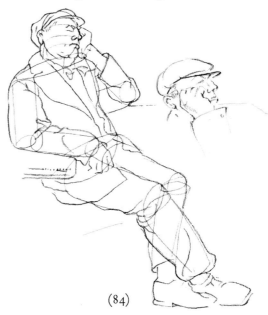

Finally, to dress our man, here is one way in which you should be able to describe how the coat and trousers go over a body — noticing the folds in the sleeves and trousers, where they occur at the elbow and knee.

(84)

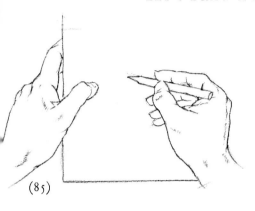

(85)

Hands and feet? Yes, these, especially hands, are well worth a good long look. A very good practice is to draw your own hands as I am now—this is my hand, holding my paper and drawing with my pencil. Two things to remember, feet and hands are both larger than you imagine, especially feet!

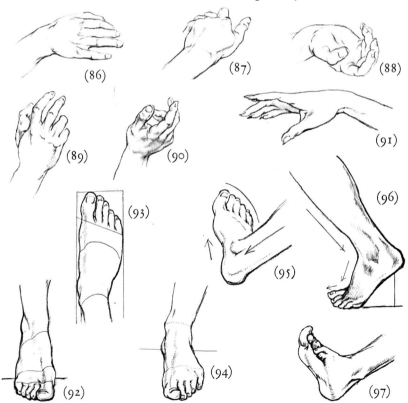

(86)

(87)

(88)

(89)

(90)

(91)

(93)

(95)

(96)

(92)

(94)

(97)

23

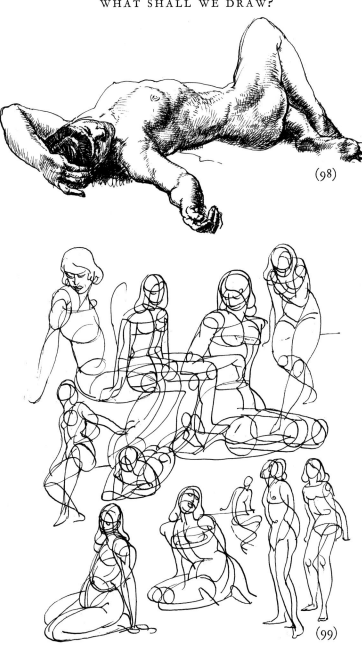

(98)

(99)

24

(100) (101) (102)

And now for the difference between a man and a woman, a boy and a girl. I know that some women are taller than men, and that boys and girls can grow taller than their parents (my son is now taller than I am), but for our purpose, we will suppose that our woman is slighter in build and not so tall as a man, not so broad at the top of the body, but the base is wider. Here then are some proportional tips for the drawing of a man, woman and child.

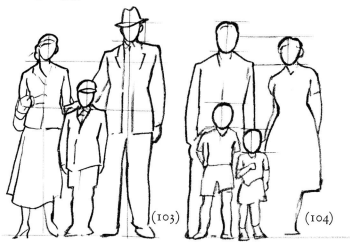

(103) (104)

Let's Draw a Horse

THE first question again is, "how does it go?" How is it made? It's certainly nothing like a human being and yet it has many points in common with one, as we shall see. Like us, it has a head and a body, but whereas we stand on two legs and have other uses for our arms, a horse has four legs to support its body. This means that the body is *parallel* with the ground. Shall we try a side view and see what this position looks like?

(105)

We shall get something like this, which is really rather a good start. I think at this point we should look long and hard at the legs, because they will show us more than anything how to make our horse look like a real one. First of all, they are made like ours, in two parts, an upper and a lower leg (or arm, because the upper part of a horse's front leg is called a forearm). The

26

joints are like our elbow and knee. Next we see that whereas the front legs of a horse bend forward like our legs, the back legs of a horse bend in the opposite position.

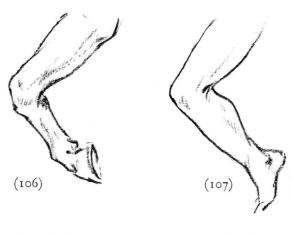

(106) (107)

Front leg of a horse *Our leg*

Even when the horse is standing quite firmly, the back legs are never quite straight, like the front legs, but are set at an angle. This is a great help, as you will notice in the next drawing.

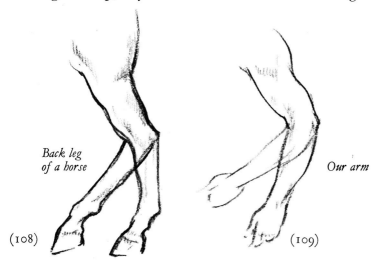

Back leg of a horse *Our arm*

(108) (109)

At the base of each leg is the hoof, and just as the castor on a chair, so the hoof is set, not in a *straight line* but at an angle.

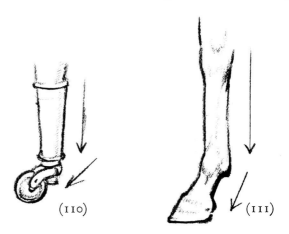

(110) (111)

Now let's go up to the head and neck. Both head and neck are long. They have to be, because when a horse is eating the grass, he has to stretch down to do so without bending his front legs.

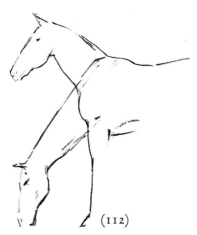

(112)

Unlike us, the nose of a horse, instead of sticking out in front of the forehead, is all in one line with it, and the ears, instead of growing at the sides, grow out of the top of the head, and are pointed, and the nostrils are close to the mouth and much wider than ours. The eyes are placed at the sides of the head and are set at a slope, and the hair, or mane, grows out all down the extent of the neck. Sometimes it is "hogged", cut short. *A.* Sometimes, like the tail, it is allowed to grow long and hangs down on either side of the neck. *B.*

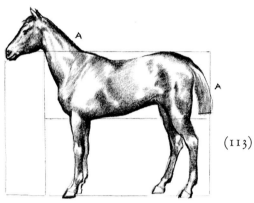

(113)

Notice the bulge of the cheek, and also the curves and where they occur.

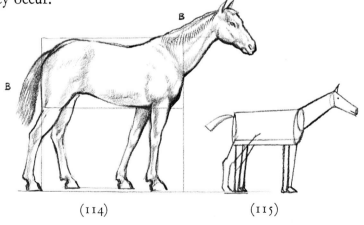

(114) (115)

29

Notice, too, the distance between the top of the neck and the chest, and the chest (x) and the front leg (y), and the shape between the front and back legs (z).

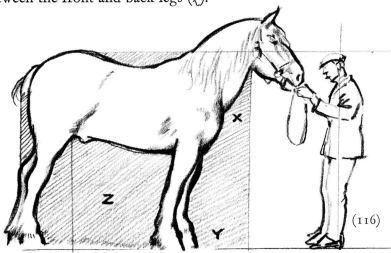

(116)

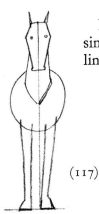

Now let us look at the horse, *front view*. Very simply, it can be first indicated in a series of straight lines and a circle.

(117)

But if we look carefully at the head, we will draw it like this, and the body and legs in the same way, taking care to notice the shape between the legs, both in the front and the back-view.

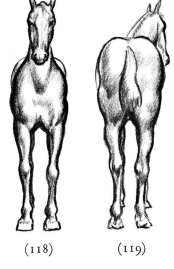

(118) (119)

30

For many years, indeed until the camera showed us in a split second what actually happened to the horse when it was at a full gallop, animal artists always drew the horse like this:

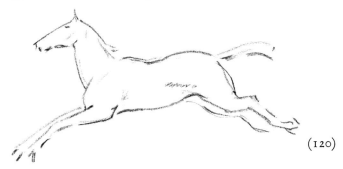

(120)

It certainly looks like this when we try and follow the movements with our eyes, but actually the four legs are never all off the ground together. If they were, the horse would collapse, for there is no other movement the poor horse could take! Now, with the help of the camera, we see that at any fixed second the horse moves like this:

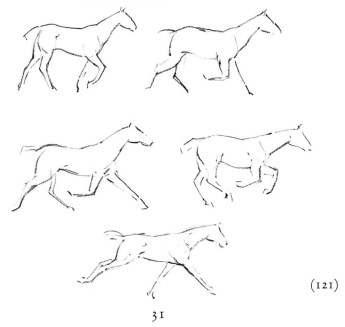

(121)

The following diagram, I hope, will explain what happens to the legs when the horse is rearing up, and jumping over a fence.

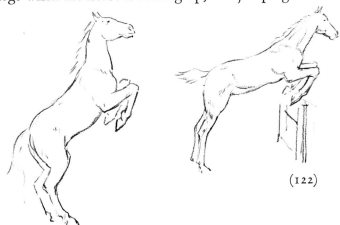

(122)

Well, so much for this noble animal, who serves us so well, and carries us on the back so quickly and gracefully, and who in old age can still be used for the purposes of our picture-making.

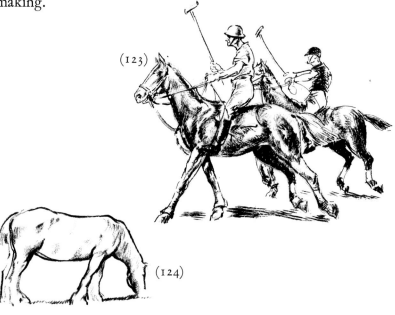

(123)

(124)

32

Let's Draw a Cow

THE cow is something like a horse, that is, it is roughly made in the same way and moves on its four legs. But if we try to draw one as we did the horse, we shall get something like this, and it somehow doesn't look right.

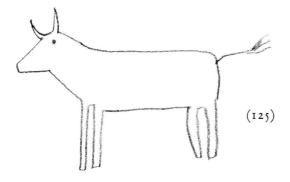

(125)

There are many differences, so let's go over them and see where they occur. First, the head is much shorter, the ears are set beneath the horns (some cows, by the way, are bred without horns), and are large and "flappy". The neck is shorter and thicker—not so graceful! The body is heavier, and when we look at the legs we find they are much shorter than those of a horse; in fact, they appear rather fragile to support such a heavy frame. Then, of course, it has udders between the back legs, and a tail which is rather like a rope with a tassel on the end!

So our second drawing, if we follow these differences, will look like this.

33

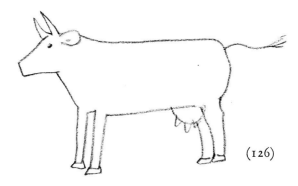

(126)

But it still doesn't look quite right yet. Now, if you look care-fully at the back of the animal in my next drawing, you will see the great difference between the back quarters of a horse and a cow. The back of a cow, instead of being curved, is cut off sharp, almost at right angles; in fact, the body can be contained in a box-like shape. Notice too that because of the shortness of its legs the cow can easily reach the ground to graze, despite the shortness of its head and neck.

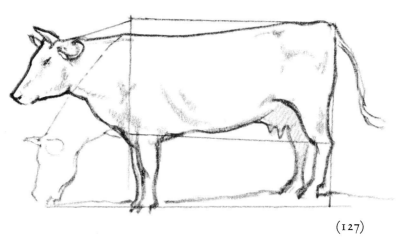

(127)

Now let us see what a cow looks like when it is coming towards us; cows are very inquisitive animals, quite harmless,

and I have actually had to push them away when I've been painting, so interested are they to see what I'm doing!

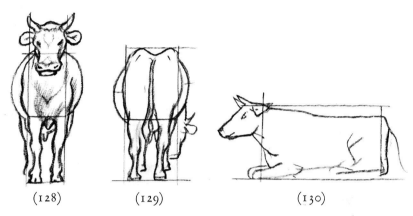

(128) (129) (130)

Look carefully at the other drawings and see how I have constructed them. These guiding lines I've put in will help you to get the right proportions of head, body and legs. These scaffolding lines will also show you how a cow looks back view and when it is sitting down.

Here is the three-quarter view.

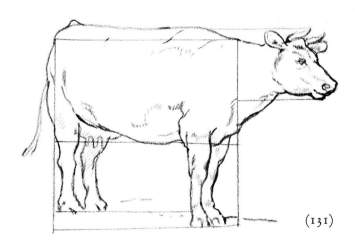

(131)

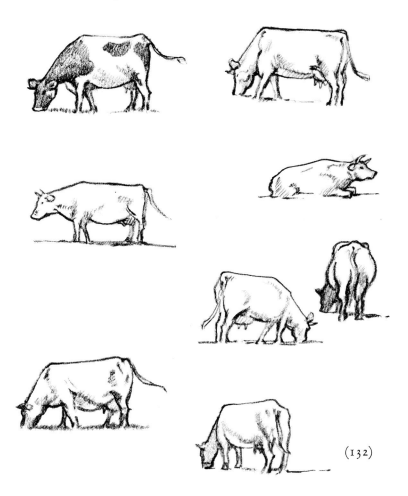

(132)

The pictures of cows are from rapid notes I made one summer—they had to be drawn very quickly because the cows wouldn't stand still.

Even more than horses, cows are always welcome in our landscapes, and we should now be better able to include them in any country scene we wish to draw.

36

Dogs, Cats, Birds and Pigs

THEN, of course, we have the domestic animal, the dog and the cat. While dogs share some of the characteristic shapes of cows and horses, being more or less foursquare in design, they can also be made to sit or stand still, which is essential when drawing them! But cats! They are a law to themselves and even when apparently asleep will suddenly change position or walk away. But whether they are curled up, or busy washing themselves, stalking a mouse or a bird, or climbing a tree, they are all grace and rhythm and worth the effort of quick studies.

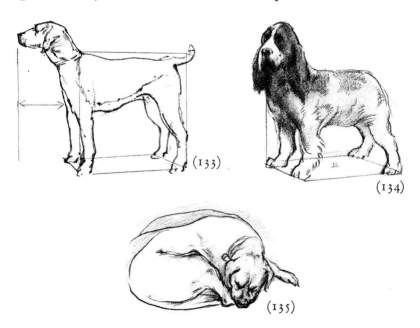

(133)

(134)

(135)

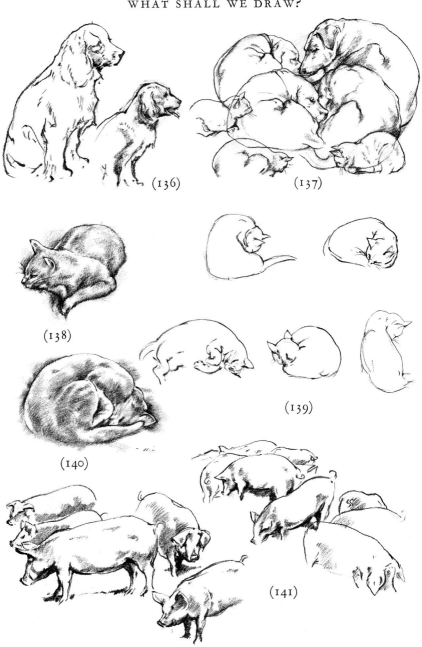

(136)

(137)

(138)

(139)

(140)

(141)

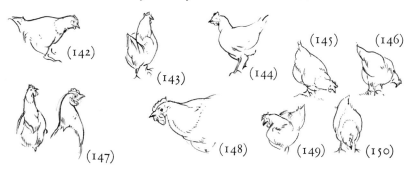

With cocks and hens and the common birds, it is even more a matter of hit or miss—their swift jerky movements have to be captured with a line. I have included the studies of swans because they are so graceful when in their true element and so gawky and awkward when on dry ground. The goose appears because it is the only sketch I have done that really resembles this comic bird.

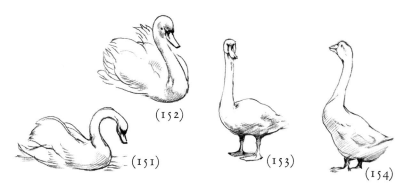

A bird table outside my studio window accounts for my attempts at following the sparrows, robins, etc. at mealtime.

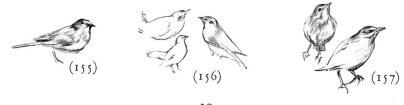

39

Street Scenes

STREET scenes I always think can make very good pictures. There are so many interesting things in them. Let's see how many we can remember.

First, the street itself, with its roadway and pavements, gutter and drain trap:

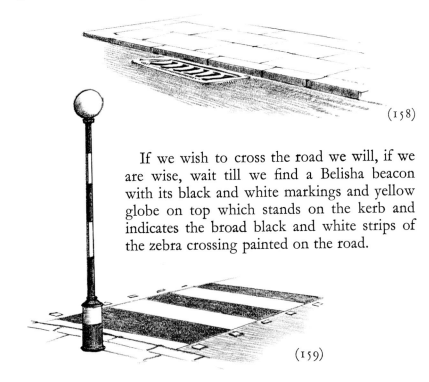

(158)

If we wish to cross the road we will, if we are wise, wait till we find a Belisha beacon with its black and white markings and yellow globe on top which stands on the kerb and indicates the broad black and white strips of the zebra crossing painted on the road.

(159)

At regular intervals on the pavement stand the standard lamps. There are a bewildering number of different designs, from the picturesque Victorian design to the strictly modern concrete type.

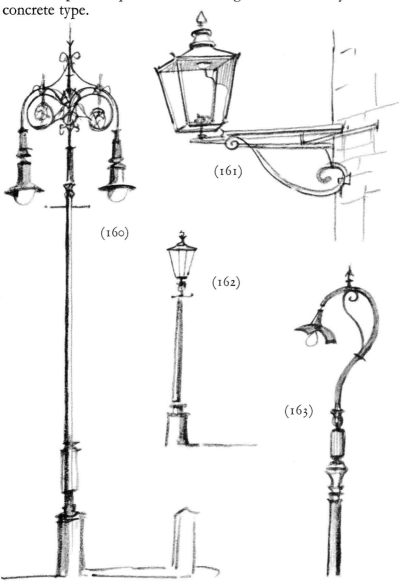

(161)

(160)

(162)

(163)

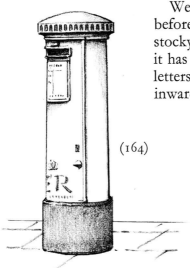

We should not have to walk far before we meet a pillar box—circular, stocky, and painted red, but remember it has a black base and the opening for letters is placed at the top and facing inwards and not on the street side.

(164)

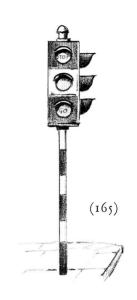

(165)

If our street is a busy one, when we come to the cross-roads we will see the traffic lights with their three coloured discs. Can you remember in what order they are placed? Red at the top and green at the bottom.

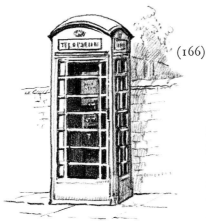

(166)

Against a wall we often find a telephone kiosk, generally red, with three sides, including the door, of glass, as you see in my drawing, and with the word "Telephone" printed over the door.

42

Sometimes trees are planted on the pavements. I wish there were more—they look so pretty in the spring and summer, and even in winter they help to decorate the street. Then, of course, we have houses, and don't forget the roofs and chimney-pots—and TV. masts

(167)

and plenty of shops of all kinds and descriptions, from the large department store to the little general shop with its crowded bow window—vegetables, flowers, ironmongery and furniture (often displayed outside and making a welcome note of colour).

(168)

(169)

In the roadway itself, a bus perhaps, tradesmen's vans, and sometimes horse-drawn carts and drays. Certainly, private cars in plenty, are seen, both stationary and on the move.

(170)

(171)

(172)

No street scene is complete without people, some window-gazing, some in a hurry, and some just standing and talking.

Try including some of the people you learnt to draw in Chapter Two.

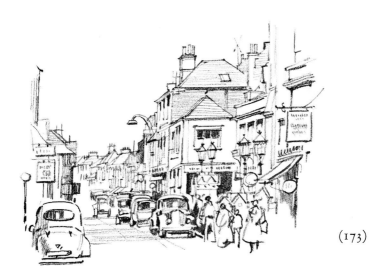

(173)

45

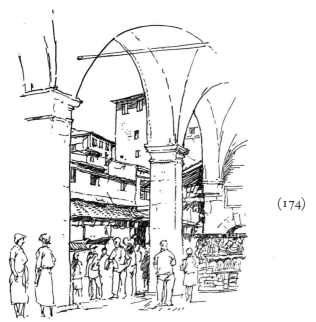

(174)

(175)

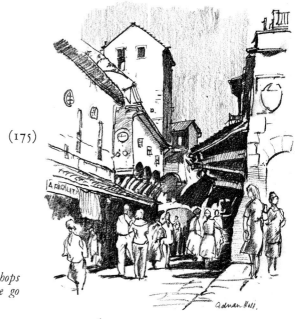

*How different are the shops
and markets when we go
abroad*

Will you look for all these various things when you next go for a walk, or on your way to or from school?

It is a good plan to compare the drawing of any of these objects you have made from memory with the real thing. "Oh", you will certainly say, "*that's* how it goes", and you will then see how to improve your drawing. If you want to look up or down the street so that it "goes away" you will have to know something about perspective, and I will make a separate chapter about this, as it can help you quite a lot.

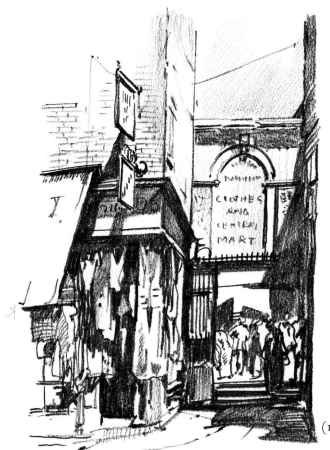

(176)

47

Perspective

PERSPECTIVE? It's rather a frightening word. What does the dictionary say? "The art of drawing on a flat surface (that's your paper) to give the effect of solidity (making it look real) and relative distances and sizes" (making things go away).

How is it done? Well, making whatever you are including in your picture—people, animals, buildings, trees—smaller and shorter. That's easy. A tall man, for example, as he walks away from us, soon becomes smaller than a short man who is quite near us. And the road that he is walking along gets narrower than it is where we are standing, although we know that the road is actually the same width all the time.

Perspective, then, is the only way to convey distance or depth in our pictures, and, as I've just mentioned a man on a road, I think we can make this our first example of how it works.

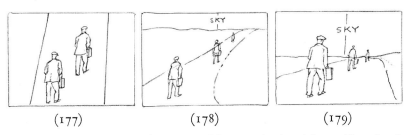

(177) (178) (179)

Look at these three diagrams. You see in (177) how if we look right *down* the road we don't get any feeling of distance, but if we show a strip of sky (178) we can then make our road grow narrower as it goes away to the horizon line, where the two *parallel* lines of the road will finally *appear* to us to meet, and

that is how we will draw them. Compare (179) with (177) and you will see how perspective works.

Now this principle of parallel lines which, if extended far enough, will meet, applies to the top and bottom of a box or a house.

(180) (181)

For example, if we see two sides of a box or house, each pair of lines will finally meet.

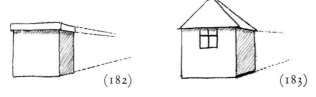

(182) (183)

If we look down on the box, so as to see the *top* of it, these two lines will also meet.

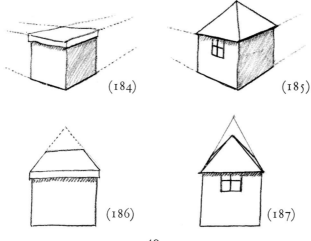

(184) (185)

(186) (187)

49

Now, which looks better? (188) or (189)?

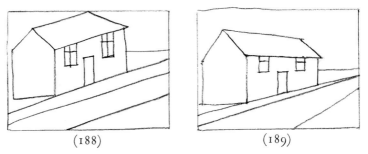

(188) (189)

One more example and I've nearly finished. You are sitting in a room, facing a wall, and on either side of you two side walls.

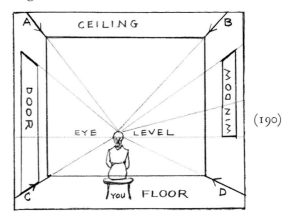

(190)

Now you will have to *look up* at the lines of the ceiling, *A* and *B*, as you will have to *look down* at the lines of the floor, *C* and *D*. So this is the rule: parallel lines that you have to *look up* to see, appear to go down, and parallel lines that you have to *look down* to see, will appear to go up! *A* and *B* go *down*, *C* and *D* go *up*. Do you follow? It's not so difficult, after all.

The four little diagrams I've drawn (191) to (194) demonstrate another rule, which you can prove for yourself, and it is that the horizon line is always on the level with your eyes. I have shown you at various heights—sitting, walking, cycling and riding, to show you how it works.

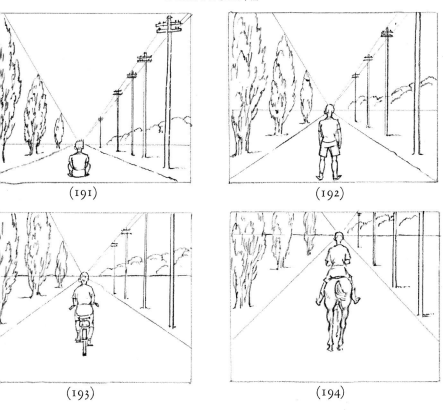

(191) (192)

(193) (194)

The more sky you show in your picture, the more distance you will get, as you will see by comparing my four little drawings

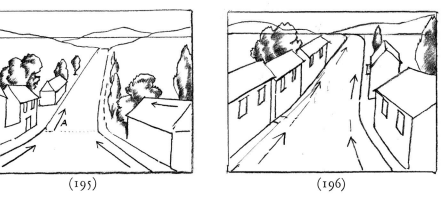

(195) (196)

Often roads go down *hill and then all our main lines have to go* up

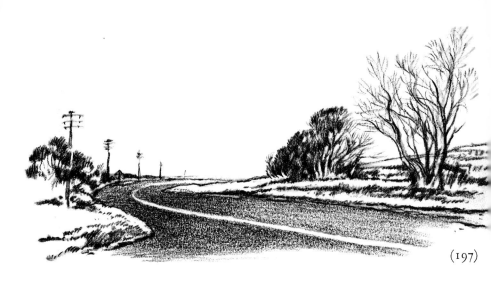

CHAPTER NINE

The Open Road

STREETS are all very well, but at their best they are generally very crowded and noisy, so it is a relief to find ourselves on another kind of road which leads us out of the town and into the country. Broad roads, curved roads which twist and turn up hill and down dale, and narrow lanes which wander about the countryside. They can all make very interesting pictures, if only we remember the sort of things we find along the road-side.

Let's follow a main road, on which we are carried from town to town by coach or car. The first thing I think we notice is the white snake-like painted line which runs down the centre of the road for miles at a time, and then breaks into regular intervals along certain stretches of its journey.

And now for the sides of the road. No pavements here, but grass verges or narrow footpaths along the banks, which are lined with hedges, broken at intervals by stone and brick walls,

wire and wooden fences, white posts and iron railings, farm gates, and an occasional stile.

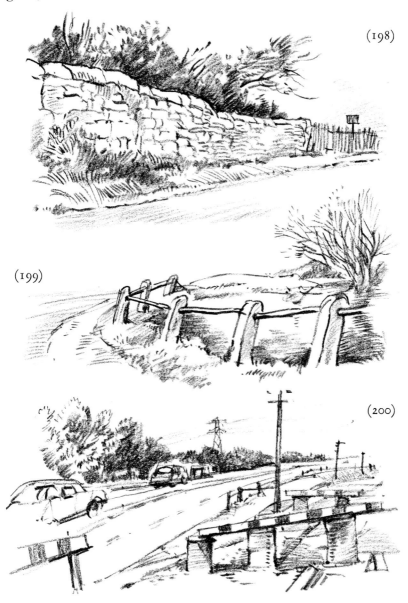

(198)

(199)

(200)

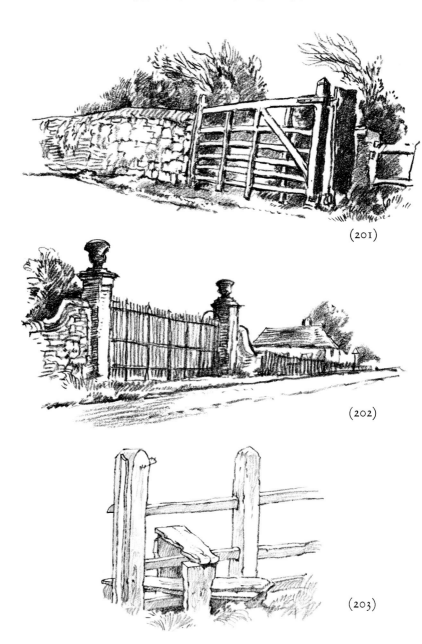

(201)

(202)

(203)

The telegraph poles which stand by the roadside, tall and gaunt, with their varying number of cross bars according to the number of cables they carry, are the tallest objects made by man in this setting, and make a distinctive silhouette against the sky.

(204) (205) (206)

Road signs and notice boards can be spotted, and always where our road divides stand the welcome sign-posts, which can be included to help the composition of your picture.

(207) (208)

I have only mentioned so far those objects which are on the roadside itself. We have to look beyond them to find all the

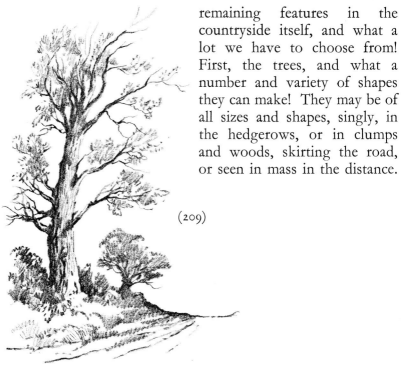

remaining features in the countryside itself, and what a lot we have to choose from! First, the trees, and what a number and variety of shapes they can make! They may be of all sizes and shapes, singly, in the hedgerows, or in clumps and woods, skirting the road, or seen in mass in the distance.

(209)

Then, all the fields and meadows, under grass, newly ploughed, with standing corn, or in well-ordered lines of "stooks" at harvest-time, and standing isolated, or in snug groups.

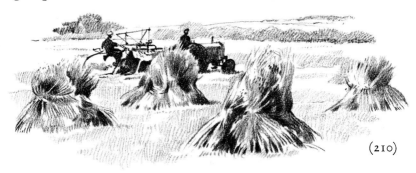

(210)

56

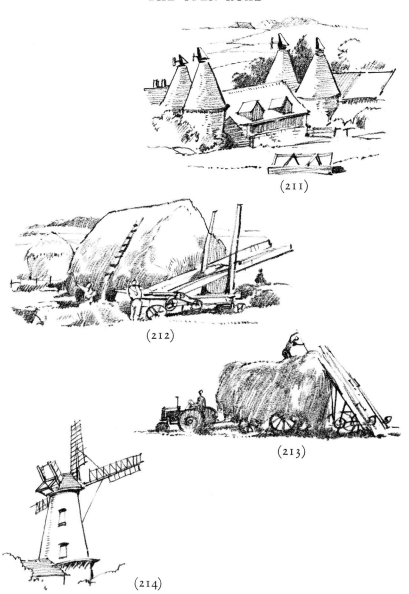

(211)

(212)

(213)

(214)

Farm buildings and haystacks, and perhaps a lonely windmill, catch the eye.

(215)

Looking through a bridge in Devon.

Streams and bridges must not be forgotten, nor the distant spire or tower of a village church.

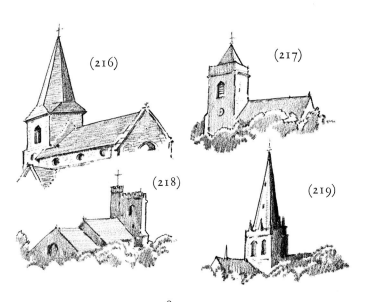

(216)

(217)

(218)

(219)

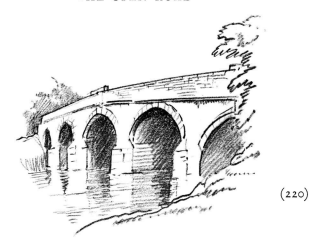

(220)

What we do realise by now is how much the countryside is changing. The latest addition to the growing number of new landmarks is the octopus network of pylons which can be seen striding across field, hill and dale. At close quarters they tower up rather menacingly but at a distance there is something ethereal about their skeletal forms linked together by long undulating shiny cables which span the horizon, and, let's face it, can lend a new enchantment to the landscape.

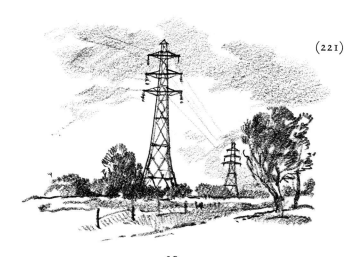

(221)

But it is on the road itself, where lorries and vans, coaches, cars and caravans speed their way (or rest awhile in the "lay-bys" provided at regular intervals) . . . it is here we find most change. Roads are straightened out and greatly widened to contain the increasing traffic. Flyovers and underpasses transform portions of our journey into veritable switchbacks. Notices, such as "Road works ahead", "Single line traffic only" and "Diversion", all warn us of the extensive reconstruction ahead, necessitating, as it does, the removal and destruction of many familiar landmarks, especially lines of wayside trees. But—and this must be our consoling thought—what has gone is quickly forgotten and in its place a new view is offered, an exciting prospect is revealed, thus producing new material for our picture-making, which will look very out of date if we refuse to integrate some of these new elements into our landscapes.

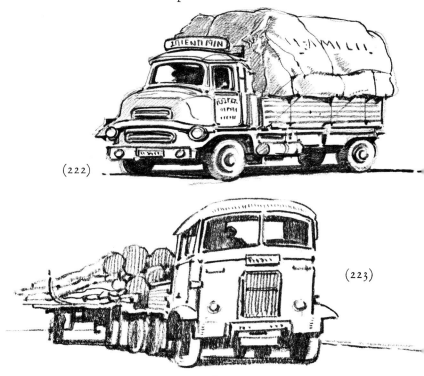

(222)

(223)

60

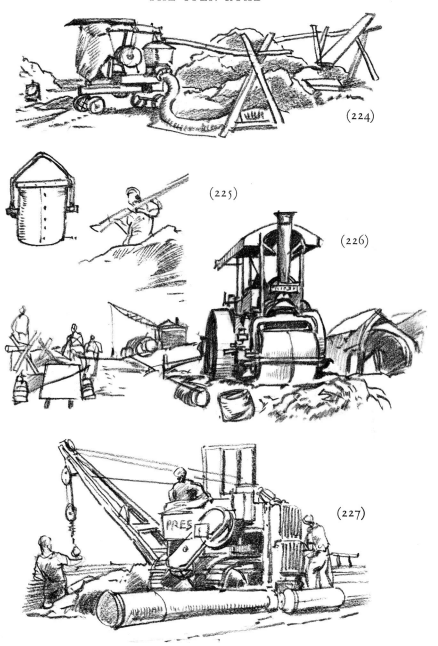

(224)

(225)

(226)

(227)

(228)

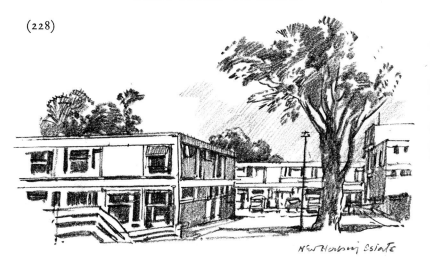

New Housing Estate

We must not forget the new housing estate or the factory that springs up beside the open road.

From such a wide selection it will not be difficult to add sufficient detail for incidents or for the background of our picture of "The Open Road". It is for you to choose, for we must not overcrowd our scene.

(229)

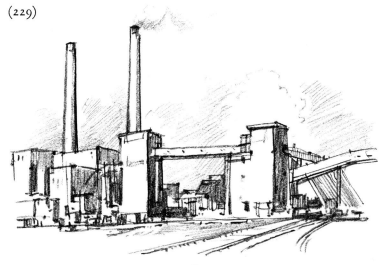

The Seaside

WHAT are the most important things we remember about our holiday at the seaside? The sea, certainly; but if we just look out to sea and make our picture of that, without putting in a boat or two, it won't be a very exciting scene. In fact, a straight line drawn across our paper is about all the scaffolding we require. Above that line will be the sky, and beneath it the water. Of course it depends on how much sea or sky we want where we draw our horizon line.

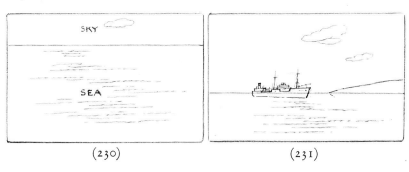

(230) (231)

In any case, we are forgetting the seaside part of our picture, all that portion which includes the sands, cliffs, promenade, bandstand, and so on. For it is there that we shall find the things which recall to us memories of our holidays. I wonder how many we can draw from memory?

First, there are the cliffs which rise out of the sands, sometimes white in colour, and sometimes reddish, sometimes sloping gently to the sea, sometimes steep and rugged, and we often find steps cut in them for getting down to the beach.

63

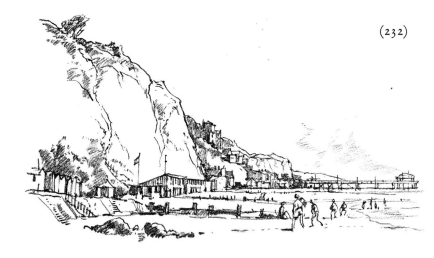

(232)

At the base of these cliffs can be found the rocks,

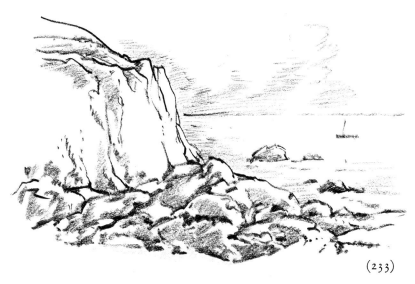

(233)

smooth and rugged, large and small, which are such fun to clamber over.

64

Then, of course, the promenade with its iron railings, standard lamps, and its shelters with seats, and we must not forget the kiosks or little shops that sell ice cream, sweets and postcards.

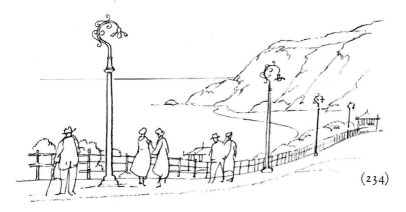

(234)

And it is on the front that we meet all kinds of people and children, walking along in the direction of the pier, that exciting

(235)

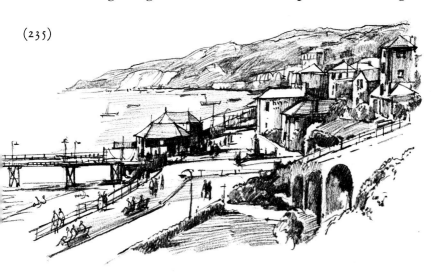

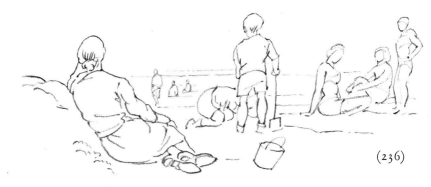

(236)

construction which, like an iron arm, stretches right out into
the sea.

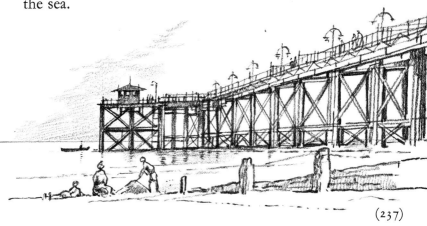

(237)

This too has its iron railings on either side, and its lamps and
seats where the grown-ups sit and read their papers, while
children run along to the very end, where there is often a
pavilion with a domed roof where concerts are held.

At night the pier looks very attractive, outlined with coloured
lights which dance and sparkle in the water underneath. That
is a very good subject for a picture. At the moment, however,
we are content to view the sea front in daylight, with its bathers
dotted about the water's edge, or sitting by the breakwaters
below the promenade.

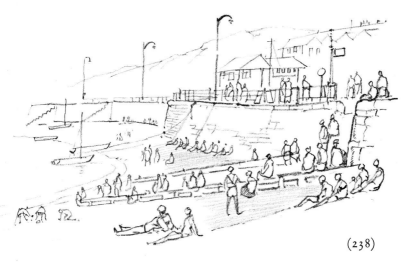

(238)

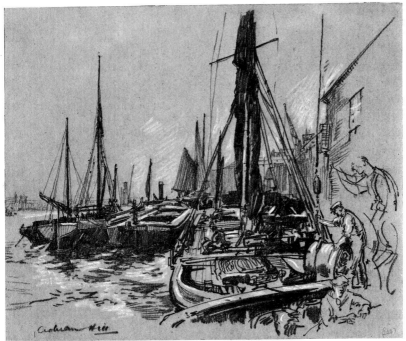

Loading at wharf. Note the technique used, carbon pencil on tinted paper with white chalk

There is more than enough on these densely covered sands, and on the sea, to make a really interesting picture—in fact, we shall probably have to make a selection, if we don't want to make our subject too overcrowded. Indeed, it's a tip to remember that in order to *complete* our picture, we often have to leave things out, and include them in another drawing. So don't put all your eggs in one basket!

Boats are fun to draw. Your seaside resort may have a harbour, and there's always a picture to be made of the stone jetty

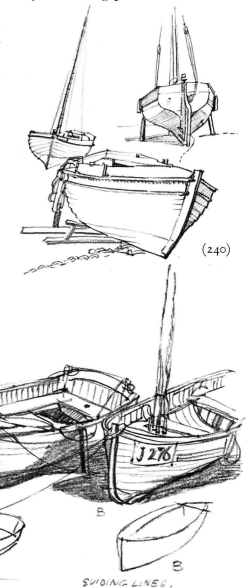

(240)

(241)

A

B

B

GUIDING LINES.

68

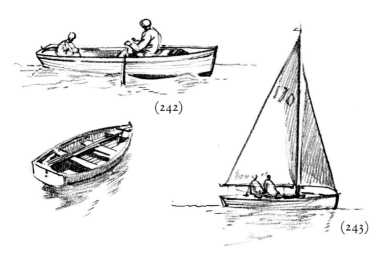

(242)

(243)

against which boats of all kinds are moored, and at the end of which stands the faithful lighthouse surmounted by its circular

(244)

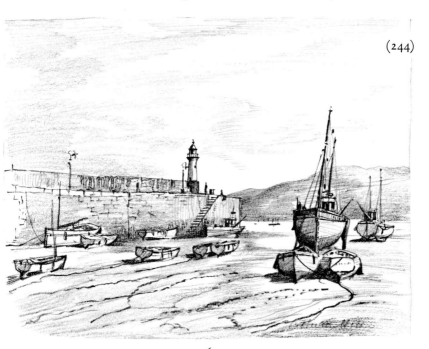

lantern and balcony. Note carefully its shape and height, and where it stands, and how when the tide is out the rowing boats lean this way and that, and look out for the pattern which the long ropes make on the sloping beach.

(245)

All you have to do now is to decide where you are going to draw your picture. On the sands, looking out towards the pier or jetty? On the pier, looking back at the cliffs and rocks and sands? On the promenade, looking towards the bandstand? Or even on a boat in order to get a closer view of a yacht anchored in the harbour.

CHAPTER ELEVEN

Let's Draw a Tree

AS trees will very often appear in your pictures I want to give you a few tips on how to draw them, because, like human beings, they also have a trunk (or body), and limbs (boughs and branches), and remember they are not always covered with leaves! Also, there is not just one kind of tree, but many, and each has its peculiar shape and character.

(246)

When we first start drawing a tree, the result is something like this (246). Just as in our first attempts at faces, people or animals, the illustration will pass for a tree, but it is nothing like a real one.

In a real tree, and we can see this better in winter when it has got no leaves, we notice that it is made up of an upright trunk, out of which grow the boughs, and all the branches, and the twigs, in that order, the twigs growing out of the ends of the branches and forming the shape of it. So we get a shape something like this (247).

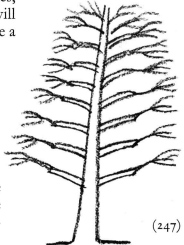

(247)

71

But the boughs which grow out of the trunk are not at regular intervals, nor do they grow out the same length or in the same direction. They are all *solid*, and I've shown that they grow out from the *sides* of the trunk, some coming towards us, and some from the other side of the tree.

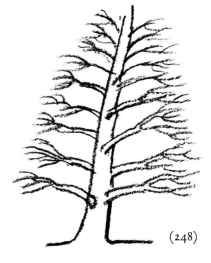

(248)

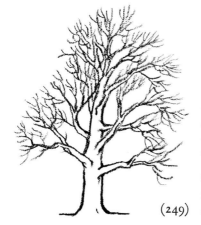

(249)

I think you'll agree that this drawing is an improvement on the others. In my next drawing you will notice how I've drawn the branches, going this way and that, and how the shape of our tree is now irregular, the outline being different on either side.

Remember that all trees have roots, and we must show that they grow *out* of the ground and are not just standing *on* it (250).

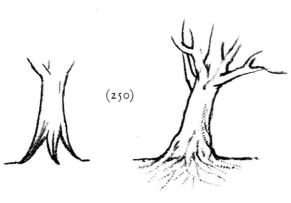

(250)

Having got to know something more about how our tree grows, we can now cover the skeleton shape with its masses of foliage. We can't attempt to put in all the individual leaves, but we can give the general impression.

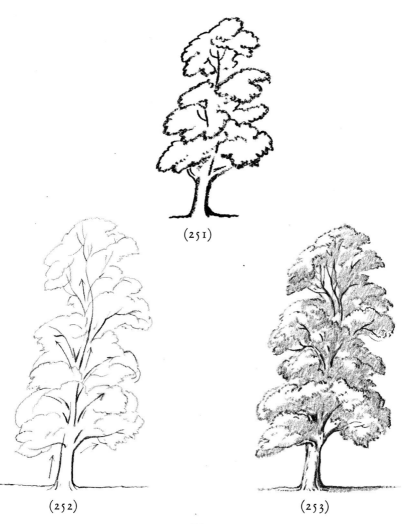

(251)

(252) (253)

If you do make separate studies of leaves, you will learn a lot about the different kinds of trees.

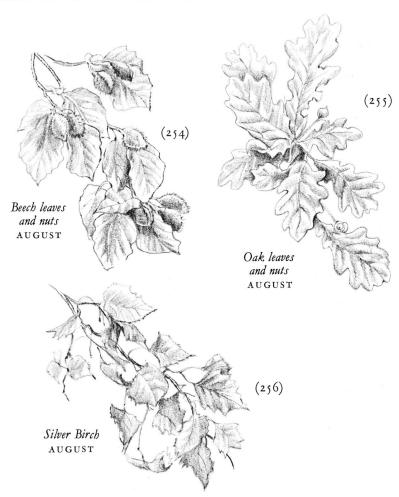

(254)

(255)

Beech leaves and nuts
AUGUST

Oak leaves and nuts
AUGUST

(256)

Silver Birch
AUGUST

This is where it is important to realize that the shapes of our trees in summer are all different. At the end of this chapter, I've given you a selection of trees which, as you will see, are very different, and all of them can be used in making a picture in which trees are important to the composition.

74

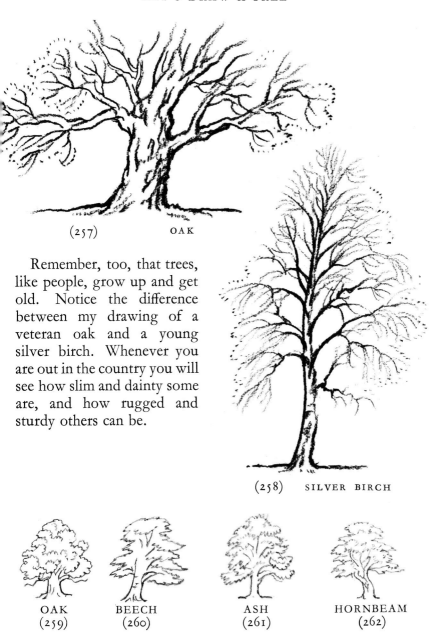

(257) OAK

Remember, too, that trees, like people, grow up and get old. Notice the difference between my drawing of a veteran oak and a young silver birch. Whenever you are out in the country you will see how slim and dainty some are, and how rugged and sturdy others can be.

(258) SILVER BIRCH

OAK
(259)

BEECH
(260)

ASH
(261)

HORNBEAM
(262)

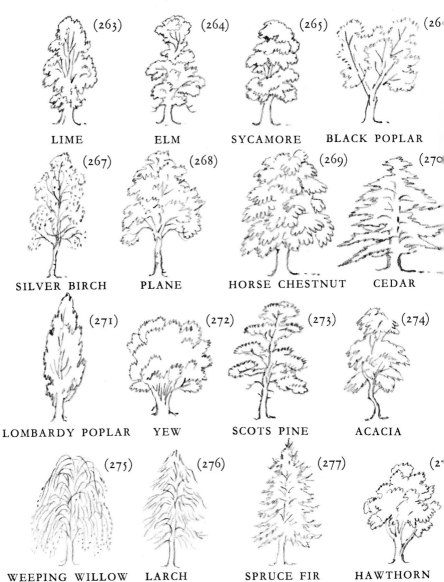

(263) (264) (265) (26

LIME ELM SYCAMORE BLACK POPLAR

(267) (268) (269) (270

SILVER BIRCH PLANE HORSE CHESTNUT CEDAR

(271) (272) (273) (274)

LOMBARDY POPLAR YEW SCOTS PINE ACACIA

(275) (276) (277) (2

WEEPING WILLOW LARCH SPRUCE FIR HAWTHORN

Oh, yes, and, lastly, notice that some trees are green all the
winter. They are the conifers, or evergreens, and their foliage
is composed of bunches of "needles" (279).

76

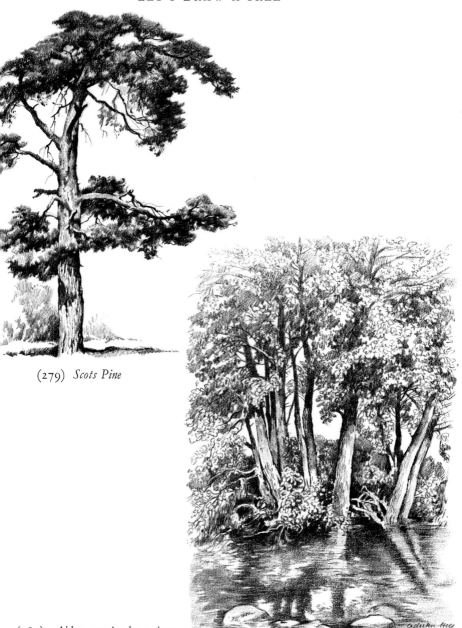

(279) *Scots Pine*

(280) *Alders growing by a river*

How Shall We Draw It?

WHEN we first begin to draw, we usually use a pencil, a lead pencil, of which there are many degrees, from 2H to 6B, i.e. from a very hard line to a very soft one. An HB pencil is most commonly used.

But we can also draw with charcoal, chalk, crayon, carbon-coute or pen and ink. We can also use a brush, i.e. pen and wash.

Now we can draw either in outline or with shading. When we make rapid studies, especially those executed out of doors and with moving objects, we limit ourselves to an outline. But there are many other drawings which we have time to complete—

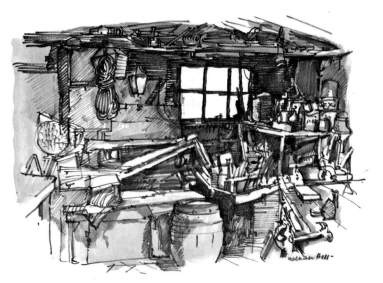

(281) *A light wash of lamp black, except for the window*

78

adding light and shade with what is known as shading—so that our drawing has tone, as well as line. It is these drawings of which I have given examples.

Drawing in line and making that line go in the right direction, under our directions, with confidence and sensitivity, is the first rung on the ladder. It is often forgotten by the student that pure outline drawing can be developed and improved by the various pressures we put upon the pencil, so that expression is added to accuracy. Try starting with a light or faint line and without taking your pencil from the paper give it more emphasis by turning it slightly when curving it up or down, or changing direction more abruptly. This will give it *life*, just as we can talk in a low voice, even a whisper, or raise our voice and even shout.

With the introduction of tone, a new quality is added, that of light and shade. This shading can be produced by the side of our pencil or chalk, by diagonal lines drawn close together, which is usually adopted when we use pen and ink, or by a wash of lamp-black, diluted with water according to the strength required.

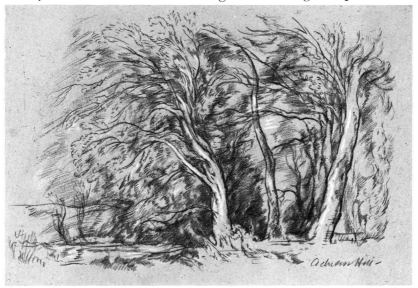

(282) *Carbon pencil on buff tinted paper, with touches of Chinese White, heightens the effect*

79

CHAPTER THIRTEEN

Conclusion

Surely our aim in whatever medium we draw in should be to "see" the subject as *we do*, and not through the eye and technique of another artist, however much we may admire his style. But far more to be resisted is the unenterprising, mechanical and laborious lead pencil *copy* from a photograph, especially a portrait. This is a dubious labour of love, so often favoured by beginners of all ages, and proffered with so much innocent pride.

Drawing from a photograph is only legitimate when great detail accuracy is demanded or when time is a factor. But a drawing done on the spot will always have the edge over that which is provided by the camera.

(283)

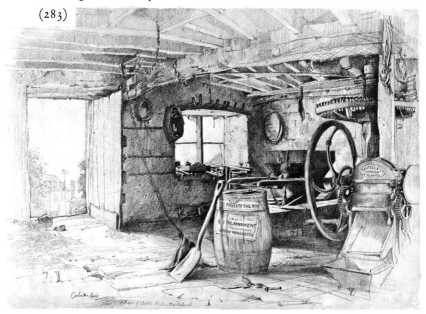